CERAMIC STUDIOS, JUMBIES AND MERMAIDS!

*A Guide To Opening
A Home Studio Like Island Screech*

By Ceramic Artist Carolyn Frary,

Copyright © December, 2012

Produced by Mark A. Wilmot, specializing in books for subject matter experts, and people with a vision for the future. For more information, visit Facebook Publications on the web – www.facebookpublications.com

Availability of the artist: Carolyn Frary is available to speak about art and home studios in the New England area. Please contact her directly through the Island Screech web site on the internet.

Table of Contents

About The Artist.	1
Why Read This Book?.	4
Ceramics Studios At Home.	7
Have A Vision of Your Future!	10
Chairs, and Cups, An Interesting Perspective.	12
Formal & Informal Considerations.	20
Studio Safety and Risk Management.	27
Studio Budget, Space, and Set-Up Considerations.	33
The Kiln..	41
Creativity & Consistency, Along With Product Quality.	45
Variation & Quality.	48
Overview of How I Work In The Home Studio	56
Selling Your Artwork..	64
Your Vision.	70
Ideas & Possibilities	71
Action Items..	72
Action items..	73
Potential Customers..	74

About The Artist

Carolyn J. Frary

Before opening her own studio, artist Carolyn Frary attended the Rhode Island School of Design where she increased her perception and appreciation of art. A leader in the field of art education since 1877, the school attracts many people who want to learn more about the field of creative design. The Providence school is one of the original art

colleges in America. When they opened their doors, they timed it to coincide with the opening of the Rhode Island Museum of Design Art, which offers a variety of changing exhibits, and free admission to the public every Sunday.

While studying at the Rhode Island School of Design, and then while working as an intern, Carolyn dramatically increased her knowledge, skills, and adoration of ceramics. Having enjoyed working with clay since early childhood, Carolyn decided to focus exclusively on ceramic art as her line of professional work. As a matter of practicality and economics, she chose to work from home. With the help and support of her husband Daniel, she established the *Island Screech* studio in the basement of their two-story house.

With raw materials, a functioning work space, and the right equipment, Carolyn earns money doing what she enjoys most – making ceramics, and selling her art far away, in exotic places like St. John, and St. Thomas islands, in shopping centers such as *Mongoose Junction*, and the galleries of *Bamboula*, *Just Imagine*, and *Style A Dog*.

In this book, Carolyn shares her thoughts about being an artist, and offers important background information about the process of getting started on your own. Those details can help others who might be considering the idea of a private art

studio, where they can stay at home to earn money the old-fashioned way -- by being creative in the process of producing hand-made, timeless treasures, and useful objects of desire.

**Carolyn and Dan Frary working together in the
Island Screech studio during November, 2012**

WHY READ THIS BOOK?

This book contains valuable background information and the personal observations of a successful artist. It sheds light on hundreds of the smaller details that artist Carolyn Frary learned about ceramics and art, not just in the classroom or living room, but also during the process of setting up her own ceramics studio. That information has been organized and published as an inspirational, self-help book for those considering opening their own ceramic, pottery, metal-working, or woodworking studios.

This book also includes a thought-provoking insight into the importance of ceramic art, by looking back on the rich history of ceramics and pottery, which, even in today's high-

tech society, are still directly tied to the advancement of civilization.

Other chapters discuss the necessary <u>thought process</u> an artist should undertake if they plan to open and operate their own studio. Opening a studio can be quite a significant monetary investment, so this book provides somewhat of an outline of the methodical steps of selecting an *appropriate* work space, buying the right types of equipment, and then explains how to go about employing *best practices* within your studio, so that it remains stress-free, fun, and sustaining.

Later chapters provide other useful information which an artist might not know. After all, many artists learn the crafts, but maybe not the business or technical aspect of things such as quality, safety, and risk management. So, this book has a little of that too, plus tips on how to uncover the hidden consumer markets which could lead to some type of profit. This material is valuable because income, and then a *profit after expenses are deducted* allows the committed artist to continue working not only on products for external customers, but on projects which the artist becomes *inspired and driven* to create, for no other reason but to satisfy the innate human need to be creative.

Ceramics Studios, Jumbies and Mermaids ❖ 6

CERAMICS STUDIOS AT HOME

Welcome to the studio called Island Screech, and this short book on ceramics and pottery. Let's learn about the possibility of opening your own *home studio*. As you know by now, my name is Carolyn, I'm a ceramic artist who founded Island Screech Studios! I'm writing this book with the help of my very supportive husband, Dan, who works with me in the studio, and Mark Wilmot, a quality advisor who is the producer of this book. Our approach to the subject of a home studio goes like this: We understand that you may have already become very familiar with pottery, ceramics, or your line of craftsmanship, and the general methodologies

involved. If this is true, then you know there's not much separating a potter, a glass-maker, a custom jewelry maker, or an artist like me. In general, most of us started out seeing all sorts of mediums, and then trying a few of them out in what could be called an experiment. It was always fun! Then one day something about a certain medium stirred something in our soul – at least it did for me, and that's when I started working on designing things like stained glass. A natural progression occurred, which moved me toward clay. This transition happened because I felt I had more freedom than I did with glass. Before long, because of travel experiences to warmer climates, I decided the tropical islands would become a major theme of my artistic passion, and that's the type of art I'm producing today in my home studio.

Opening a home studio is a serious undertaking! Just the cost alone could be prohibitive, but there are ways a determined artist can work through that barrier and achieve success.

To start off, understand this reality:

Nothing happens overnight. It takes time to do it right! So, read this book, and start thinking <u>long-term!</u>

√ Talk to family and friends.

√ *Develop your vision.*

√ Share your vision.

√ Ask for the support of family and friends.

√ Brian-storm with family and friends

√ Then, <u>move forward one step at a time – do it right!</u>

HAVE A VISION OF YOUR FUTURE!

The second element of advice I have for fellow artists is this; even though there are huge amounts of information and resources out there about ceramics, pottery, and everything else under the sun, don't believe for a second that everything has been figured out, and everything has been made. There is still room for you as an artist and craftsman! There is still a new way of doing things, a new creation to be made – a new contribution to civilization and culture!

With those first two pieces of advice in mind, please read the next two chapters in order to stimulate your mind for a

vision to develop, by looking at the past and matching it up to who you are as a person. When you are done, take a few days to reflect on what is said about *culture, and brainstorm with your supporters*.

As much as this book is about the basic fundamentals of starting and opening a home studio, it is also about the individual, and their innate human ability to have a dream, to take action, and to shape their own destiny.

So, the easiest, but most critical action for you to undertake while you read this book, is to identify and develop your vision by writing it down on paper (the last pages of this book allow you to do exactly that);

> *"Think about what you want to do – what you want to create, what your theme will be, and then of course, a list of things you will need, and an estimate of how much time you honestly have to dedicate to key tasks which surely will be involved, then begin defining your identity as an artist, and begin the work toward the achievement of your vision, by taking one step at a time."*

CHAIRS, AND CUPS, AN INTERESTING PERSPECTIVE

Before jumping into more advice concerning the operation of a home studio, I have to ask you to consider just a short historical perspective of two common things in our lives – chairs and pots. If you think about these everyday items, the history of pottery and ceramics is *absolutely* fascinating!

If I'm correct, making something out of clay is one of the oldest types of manufacturing known to mankind. It kind of goes along with the mandatory activity of gathering and packing food away in a safe place so we have something to

eat when we are hungry. Making objects, such as the butter churn container pictured below, and then storing food in them separates us from animals. On the other hand, it could be argued that people are no different than animals in many ways. That had to be partially true thousands of years of ago when all sorts of creatures wandered around a planet that had no roads, no buildings, and no stores. But then a divergence, or change took place, in some unmarked moment of time, when human brains began developing creative ideas, and these creative ideas allowed *culture* to emerge.

**Ceramic French-style butter churn containers
made in the Island Screech studios**

Culture can be defined as taste, manners, habits, appearance, and even physical objects or things preferred by a social group. As more and more creative ideas were born in the human mind, it slowly separated the human from the beast; we became *civilized, leaving the animal kingdom far behind.*

Yes it's true that animals such as hard-working beavers have the ability to build large dams made out of logs, which they cut down with their sharp front teeth. And those beavers live inside their self-constructed homes, generation after generation, but they have never progressed to another advanced stage of living. Despite the clay at the roots of trees which the beaver takes down, the beaver simply has not developed the *vision* or ability to use clay to make bowls to eat from, or sun-baked tiles to place atop their dens. And even though its common for birds to intricately, and almost scientifically weave grass, twigs, and string together in the shape of a oblong nest, in which they raise their young, birds have not managed to develop an advanced culture, by using those same nest-building skills to make a blanket, or a rope. So we can see separation of man and animal because of creativity, and developing tastes, and *ideas of things*. We can imagine early humans crossing frozen tundras, and rain soaked valleys in search of food.

Exhausted from this never-ending quest for survival, they would no doubt pause to rest, probably crouching, or laying on the ground, or by sitting on a rock, or the rounded edges of a fallen tree. At some point, a person, through creativity and vision, came up with the idea of *making something* to sit on. This object became known as a chair! The creation of this object of modern life, which we take for granted, sounds simple, but if you consider this example of a *thing*, then you can see that the creation, and evolution of the chair is a *miracle of culture*. Thousands of years passed since the first chair was made. Now we literally have thousands of different types of stools, chairs, rockers, couches, love seats, benches, and even car seats, and high chairs for infants to sit in. So when it comes to culture, we have to admirably consider that thousands of years ago, a man or a woman, with the same creativity and vision which brought us the chair, also generated other ideas which led to the use of raw natural materials, and the creation of cups, bowls, and ceramic tiles.

The Surf Chair by Kenneth Lylover, available at BornRich

The first documented use of containers made out of clay, designed to store water and basic food supplies, occurred about 10,000 BC. Through experimentation, and trial and error, our distant ancestors learned to shape clay into different types of items. One "thing" was the creation of a hand-held square, or what is known as a "brick."

The brick is basic; it's an easy to lift, sturdy, and versatile product brought to us by an early artist. The Great Wall of China is constructed of more than 3,500,000,000 hand-made bricks. And the common brick is still used around the world to construct homes, and school and office buildings that can

withstand the most powerful storms. As more
experimentation took place over the years,
other products emerged, including a product
called "glass" which was an outcome of
overheating the stone ovens which were being used to make
bricks and pots. The overheating of ovens was common
years ago because of a *variation* in fuels being used for the
fire, and a lack of temperature gauges, and the absence of
vent and fuel controls.

Glass windows in the home by Mentor Window of Ohio

By the time the Industrial Revolution came along, control of fire and temperature was well-regulated, as was fuel. Plastics were invented, and the cost of production went down, and more products were invented. The commonality and instances of people actually making pottery and ceramic pieces decreased. This made sense. Newer products had modern appeal. Some were even unbreakable, making it seem as though the days of pottery and ceramics were gone forever.

But the truth is, the creativity of the artist began to be overlooked as the machines and computers took over. This is a condition which cannot exist because the human mind is a miracle – it must continue to create, so it didn't take long for modern humans to re-discover the beauty of an object that a person makes during a lengthy process as is case when making ceramics.

To appreciate these points, all one has to do is to visit a museum and examine the tremendous amount of culture that exists, and to view what people have made from clay. This is why there is a re-emergence of artists who create and sell items made from clay. But the artist is not the only person enjoying ceramics these days, for everything from touch-

screens on our cell phones, to highly-durable, heat resistant tiles on the space shuttle, remind us all that clay from the earth – sifted, shaped, and baked, still adds to human culture, and this is because of creativity and vision of the human mind.

Space shuttles use ceramic tiles to deflect heat upon re-entry into the earth's atmosphere

FORMAL & INFORMAL CONSIDERATIONS

Now that we looked back 10,000 years on the emergence of clay, chairs, and culture, and you consider that I'm a clay artist, and that I like the tropical islands, please allow me to give you an overview of how I work from my home studio. The remainder of the book, starting with the next chapter on safety, presents techniques, best practices, and informal information mixed in along the way for two reasons; First, to make sure you, your family, and your pets are safe, and then to show why personality as an artist must be considered as you examine how mood and method effects work, production, and results.

Secondly, I want to illustrate the difference between doing things you have learned from textbooks and class rooms, to doing what comes natural from within, in your own mental space and creative zone, using myself as an example.

Profound Knowledge – Where Is It?

By approaching the subject of setting up your home studio this way, I intend to stimulate both sides of your brain. Trust me! It will provide you with more insight, and knowledge – just what an artist needs!

By illustrating things from various perspectives, we gain a glimpse of *profound knowledge.*

Profound knowledge is a *body of information*. It's created by knowledge and experiences, combined to the methods, materials and equipment in a process. Why is this important? Because your ability to gain access to profound knowledge impacts your future production, and most importantly, the *quality outcome* of your work.

An Artist's Motivation

Another purpose of this book is to motivate you, so before we jump right into safety in the studio, let's touch on the subject of your motivation, karma, and destiny as an artist, again using myself as an example.

Motivation is the psychological feature that arouses an organism to *action.*

We need motivation as an artist, because it brings our ideas to the surface, and then it provides the energy to make it become an object, but exactly how do we access it, or get more of it?

When it comes to my existence as an artist, I have to say I really discovered my creative self after experimentation, travel, and of course, after a great deal of reflection. It was only then, that my energy level, and creative enterprise increased. Then I began to *focus my effort* on a product line under the Island Screech brand name, consisting mostly of mosaics. Some of my creations are abstract, and some are actual objects, i.e. a gecko, a mermaid, or a jumbie, with abstract art incorporated within that object. I've included a picture of my ceramic mermaids and Dancing Jumbies in this chapter as examples of my creativity and focus.

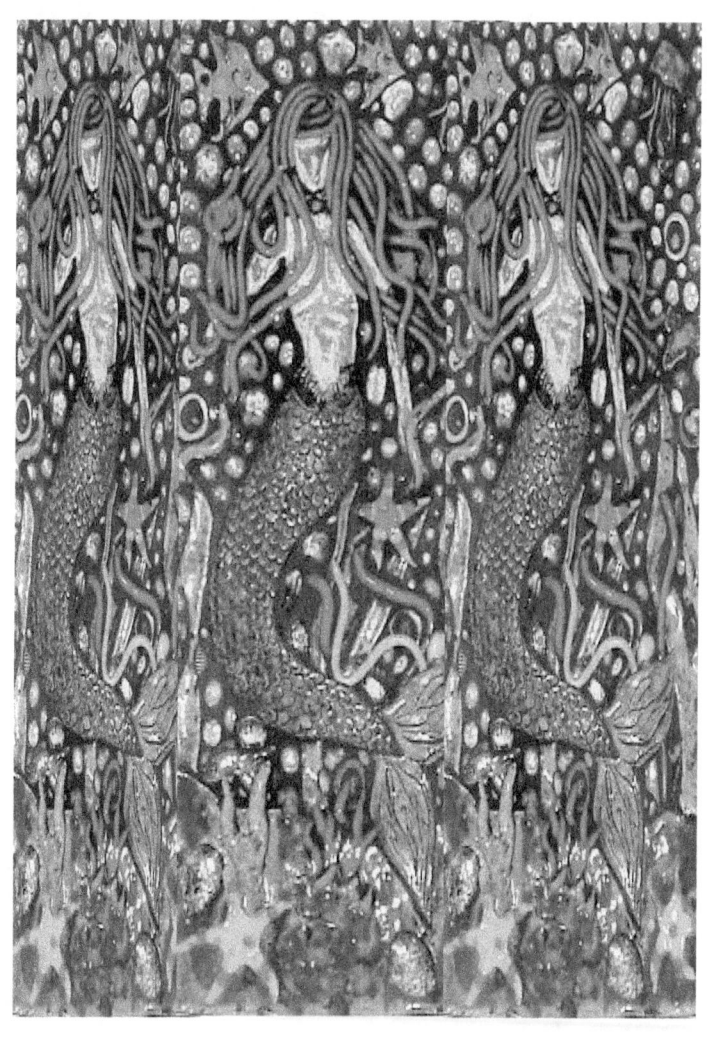

"Mermaids" an original creation by Carolyn Frary

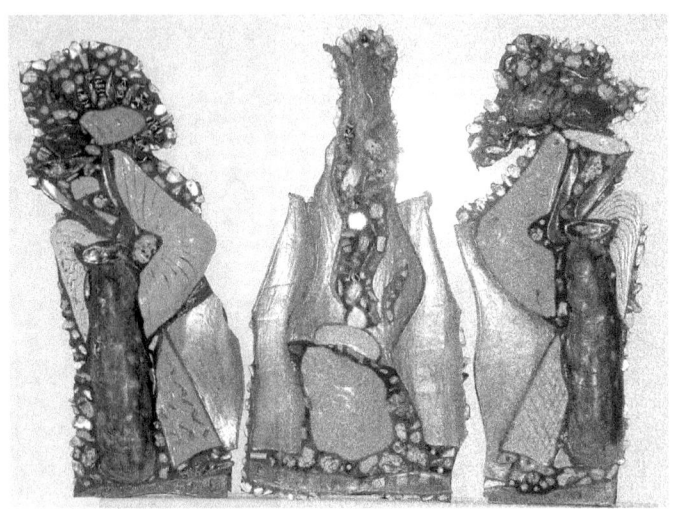

"Reggae-rasta," original ceramic artwork available only from the Island Screech Studios

The Island Screech product line *motivates and inspires* me because I love bright colors and interesting patterns. But also because I'm inspired by the mystical things found in the Myan and Egyptian cultures. I appreciate the whole world of Hieroglyphics. My fascination of these specialities arose because I am inspired by the ocean, the tropical islands, and Caribbean music and culture. Who knows – maybe I lived there in a former life! Anyway, it's my karma, and destiny as

an artist – it's in my soul. I'm inspired by the meanings behind cultures, especially in the case of the Jumbie! The word "Jumbie" has several meanings. For example, *Mocko Jumbie* refers to ancient dark spirits. One legend states that Jumbies were placed atop stilts at the entrances of villages to guard against approaching evil. Jumbies are rumored to sometimes possess humans during Jumbie Dance ceremonies. The Jumbie folklore is normally associated with the English-speaking Caribbean islands that were colonized by the British. Imported slaves, taken from African villages against their will, practiced "Obeah", a form of mystical wizardry that encompassed their traditional beliefs. Those beliefs merged with European customs as years passed.

Today, inhabitants of the islands enthusiastically embrace the Jumbie folklore, especially during parades and celebrations. Several performing art schools provide instruction on Jumbie culture to children or agile adults, who dress in colorful costumes, then get up on ten foot wood stilts. What fascinates me is the contrasting imagery which the Jumbie folklore presents; Western culture imagines ghosts as transparent white figures, gliding effortlessly across ponds, and through walls, whereas the Jumbie is dark, yet colorful, and gracefully tall, moving cautiously in parades and festive ceremonies.

Limited production *Dancing Jumbies*

STUDIO SAFETY AND RISK MANAGEMENT

Let's face it; if you plan on working inside a home studio in the near future, then you should understand that safety must always remain a priority. Please let me cover a few important things to know, especially an easy to use, five-point system for managing the risks you may encounter in your studio. We have all read crazy newspaper articles, and seen the wildest stories on television, which support my point that "stuff happens."

Much of the crazy, out of control stuff in life can be avoided by applying *risk management*.

Hazards & Risks

I'm not really a technical person, but in this case, I'm going to be a little more formal than usual because the topic is so important;

Let's start with defining hazard and risk;

A hazard is a condition with the potential to cause personal injury or death, or property damage, or the lessening of your success.

Risk means a chance of something happening because of a hazard. In the arena of the home, risks and hazards usually involve danger of harm to a person, or to your property. It could be you, or it might be your sister's child, or your pet.

For example, if you have a swimming pool in your yard, without a secure, child-proof, fence surrounding it, then the simple existence of the swimming pool <u>creates a hazard,</u> especially to the unsupervised, exploring child, who loves to wander around and get into mischief. There is a <u>high risk</u> that a child could fall into the pool and drown. This is true, even if you don't have any children.

Proof of this constant danger is well-documented by the United States Center For Disease Control and Prevention (CDC). Their statistics show that on the average, two

children accidentally drown every day in America. Isn't that shocking?

Swimming pools are not the only danger to a child because small children are also known to occasionally drown in wash buckets! The fact is that toddlers and even older children, are very curious. While exploring any home, garage, or basement, an unsupervised child could fall into a bucket headfirst. They don't always have the strength, or agility to stand back up after falling. If the bucket the child falls into contains water, then this simple event becomes an accidental drowning in the home. Like swimming pool drowning, these types of accidents are preventable through risk management.

Because I want you to have many years of success in your studio, the recognition of hazard and risk becomes an important consideration for the avoidance of injury and property damage.

Five Step Process of Risk Management

Use the following five steps in the planning and operation stages of your home studio. *Make safety a non-negotiable item;*

❐ **(1) Identify hazards, or in other words, consider all aspects of current and future situations, the environment, and known problems in any particular area.**

For example, you will have a kiln in the studio. Kilns use fuel or electricity. That creates hazards and risk. Kilns also produce heat. High heat creates a hazard of fire, and burns to the skin, so you must look at the kiln as if it were a swimming pool, and understand that accidents can always occur unless safety is made a non-negotiable habit!

❐ **(2) Assess the hazards to determine your risks.**

Assess the impact of each hazard in terms of probability and severity. Probability is the likelihood that a hazard exists, or will occur, and that hazard will lead to a less desirable situation in your activity, status or life.

Again, consider the kiln as a fire and burn hazard. And consider toxins which could harm a child or pet if they were to ingest a substance, and consider all those seemingly insignificant things, like particles and dust in the air which might cause present some unforeseen, and invisible danger.

☐ **(3) Once you identify hazards, and assess them, considering them in terms of the likelihood of something happening, and the severity of the outcome, develop a plan of action, or actions that will "eliminate the hazard," or "reduce its risk."**

For example, install your kiln on a fireproof stone surface, away from the wall, and then install a fireproof surface behind the kiln. Another example is use of storage containers, and how you place them on a shelf. Store your glazes, and adhesives in locked cabinets, or high enough that a toddler could not gain access to them, or make sure a child can never have access to your studio.

The key point to remember is that you must get in the habit of reducing your risks to a level where the benefits of your action outweigh the potential cost, and this is done best when you plan the design and opening of your studio.

☐ **(4) Implement your plan, or put your set of controls in place so that you are eliminating any hazards and reducing the risk of injury or a setback to yourself.**

Just a reminder, this safety philosophy includes the small things too, like lifting up objects (even a light object, lifted

incorrectly, can cause a back injury), and using a stool, or a ladder, or going up and down stairs, can present a risk.

❒ **(5) Evaluate the controls and actions that you put in place from time to time and adjust them as required so that continue moving toward a better position and hopefully greater success.**

Studio Budget, Space, and Set-Up Considerations

Start-Up Costs

Okay, now that safety is under control, let's get down to business about start-up costs and equipment. The minimum start-up cost for a home studio is approximately four-thousand dollars, depending on the price of the kiln you choose. However, if you want to really do it right, let's get more realistic in the planning process; plan on spending ten thousand dollars for an adequate kiln, and associated electric work, plus other equipment, tools, (brushes, wire cutters, tile

cutters, rollers, shapers, knives, sanders), and work supplies, mixes, glazes, clay, paints, stains).

Work Space

I can't stress it enough that you want to feel comfortable in your studio, and you want it to be functional, and you want it to look nice for family and visitors. So use the information in this chapter to get off to a good start in your studio. Doing so will also ensure you can control and enhance your peace of mind and mood, which affects your creativity!

With a rough budget in mind of a few thousand dollars, you have to start thinking of a space to put all the stuff in. And you have heard it before; you can never have enough space!

Unlimited space is a luxury many of us don't have, so be realistic. Understand that we can make any space work, as long as we plan ahead, and organize, and stay organized, especially when it comes to setting up a good work flow.

First, Start With An Empty and Clean Room

Plan on starting with an empty and clean room. If the studio is going to be located in the garage, or basement, or other large room within the home, empty everything out of it first!

This is the time to clean all surfaces, fill holes, and paint walls, and woodwork. Repair all loose boards, flooring, and ceiling tiles, etc.

Studio Diagram & Equipment List

After everything is cleaned up, and maintained, use a large sheet of heavy paper to map out the studio layout.

Draw a diagram of the room, then sketch the location of the kiln, sink, spray booth, and other major equipment, appliances, and tools. This is a good time to make up your equipment list. Write everything you have, then add those items which you have been planning to purchase. The next page shows a list of items for reference purposes. Consider what you want to have next to the kiln, and what cannot be near the kiln (fire hazards).

Equipment Considerations

Books
Clay
Craft Supplies
Dry Materials / Liquids
Equipment
 - Extruders
 - Mixers
 - Pug Mills
 - Scales
 - Sink Traps
 - Slab Rollers
 - Spray booths
 - Ware Carts
 - Wedging Tables
Finishing/Repair Station
Gift Shop For Guests
Glass

Glaze Room
Glazes & Underglazes
HydroBat
Kiln Parts
Kiln Room
Kilns
Mason Stains
Mold Room
Sculpture Supplies
Services
Skin Care
Stilts
Surface Decoration
Long Tables
Tools
Wheel Parts
Wheels

Lighting

Repair all electrical outlets, and check your lighting! Make sure it is bright enough, and that it illuminates the entire room. If great lighting does not exist, consider another studio space, or have better light fixtures installed. Good quality fluorescent lighting is better than tungsten bulbs. If you can afford it during start-up, it's well worth the investment – think long-term!

Sinks & Plumbing

A deep sink is needed in a ceramic and pottery studio, and obviously, this has to be planned out right from the start.

After the lighting requirement is addressed, then consider where to put the sink, and especially consider, how high it should be according to your height. Bending over all the time to use the sink hurts the lower back, so calculate an appropriate height for your comfort, and then build a platform, or use bricks to adjust the sink up to a comfortable level.

Once sink location, and sink height are established, make sure to set up an easy to maintain system of traps to prevent all the stuff that cannot, and should not go down the drains.

Set up traps where they are easy to see, and easy to empty, probably not under the sink. Use the internet as a technical resource for the sink installation, and trap design, or contact a plumbing professional.

Spray Booth

The spray booth is often an overlooked item during the home studio start-up.

Spray booths costs between five-hundred and one thousand dollars, however, as with everything else in life, a determined artist can improvise by building a spray booth by using a portable shower stall, or boards from the lumbar yard.

Venting, lighting, and over-spray considerations are what is important when you set up the spray booth. Sounds complicated, but it's not. Look on the internet, and you will discover that all the necessary information is there. After reading over it, take one step at a time! Don't rush!

Air-Flow and Venting

Think carefully about your air flow and venting. If the studio is to be located in a home, set up a system where air flows from the living quarters, thru the studio, to the outside through a fan vent, vent, or window flow system. Design your kiln vent system to vent toxins and vapors outside. (I have one on my kiln and will not operate the kiln without turning the vent system on) This protects everyone from odors and vapors, plus it helps keep the home clean!

Work Surfaces

Make sure you have enough table space. You will need wedging tables if you plan on hand building, or wheel throwing pots as you need to get the air out of the clay so it doesn't explode in the kiln.

Design your table layout so more than one person can work comfortably at a time, and that more than one task can be accomplished at one time.

Take into consideration where you can place green-ware, or half-finished products while they dry, as this affects production.

Shelving & Cabinets

Next, consider shelving and cabinets. Remember to make good use of space. Go as high as you can safely reach, with shelving. Make sure it's sturdy – especially if you live in an area prone to earthquakes. It's always best to attach shelving to the walls with screws and/or wire which will prevent the shelves from tipping over, and crushing you, or your art work. Consider purchasing wire racks because they are great for drying pieces in preparation for a bisque firing.

Organization of Your Tools and Supplies

At this stage, you are ready to figure out where you will put your slab roller, clay, glazes, dry materials, mill, mixers, scales, and so forth. Remember the process and work flow so you are not making extra trips back and forth. Make adjustments when needed.

Audio /Video Considerations

If you enjoy listening to music while you work, why not install a good system now, when the room is empty? Installation of a nice surround sound speaker system, and associated wiring, and maybe a television is a wise move.

THE KILN

The kiln is probably the most important and dangerous piece of equipment used in your shop because it gets very hot, and uses a lot of electricity (a collection of invisible electrons rushing through a wire). I actually have two kilns. The smaller one, pictured on the next page was my first. It works great, so I kept it, even after upgrading to a larger kiln. Having two sizes of kilns works out fine because I'm able to use the small kiln for test firing, plus it's capable of firing glass, while using less electricity than the large one.

There are several actions you can perform to ensure your kilns are operating and maintained correctly; First, check your power supply before installation, then re-check it periodically afterward because things change. Homes are wired to the main electrical box with a rating of 240 Volts, but public buildings and industrial/commercial buildings are wired for 208 volts. So, if you should happen to purchase a used kiln, make sure you understand about the power supply requirements and differences in case it was installed in a building. Ask an electrician!

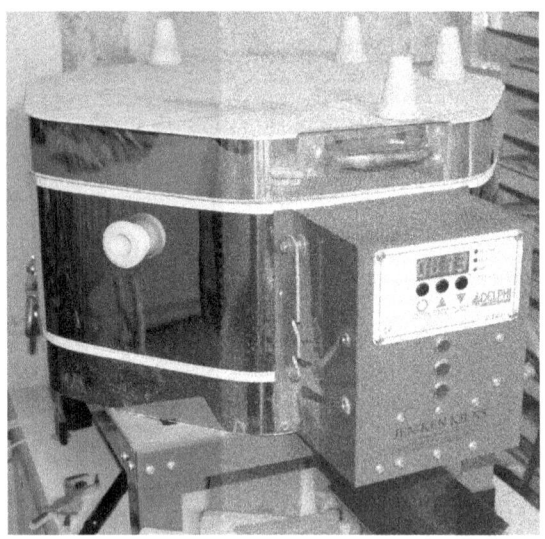

Another factor is the distance between the power source and the kiln. If the distance is greater than 25 feet, there could be a difference in power flow. A licensed electrician will know if you need to change the size of the conducting wire to compensate for longer distances. Step two is to inspect the power outlet where the kiln is plugged in. Make sure it's installed correctly. If that's okay, inspect the power cord, inch by inch because sometimes cords become nicked or sliced, creating a shock and fire hazard.

After inspecting the cord, and plug, and making sure you have good power flow, you can test the heating elements of the kiln by performing a tissue test. Simply place a tiny piece of tissue on the elements, then turn on the kiln. The tissue should catch fire, causing a little puff of smoke. If the elements are going bad, which is normal after time, they will begin to appear a dull ash gray color. It's mandatory that you have an extra set of elements, and a thermocouple on hand because, they will go bad just when you are under a deadline to make something. The reason you replace the elements on a regular basis is to maintain efficiency and even firing.

Last but not least, keep an eye on bricks and seals, as they too will become fatigued. Check the vent system – make sure it stays firmly attached, free from leakage, and that animals are not making nests in it between uses!

CREATIVITY & CONSISTENCY, ALONG WITH PRODUCT QUALITY

My philosophy is that there are "no mistakes" in the studio. Everything is an experiment, and I continue to learn as I create. This is the fun part! On the other hand, remember that variation is inherent in all things, and so is the future. Consider this; Even while I'm in this stage of having enough to do with the Island Screech products, I realize I must look to the future. Sure, I had a vision, and I settled into what I love, but just the same, I want to accomplish more!

So, while I'm enjoying my current work, and improving my skills, I keep an eye out for the future. The reason is

obvious; I'm doing what I like to do, and earning money, but I must look for other opportunities. Some of the things I'm looking at as this book goes to print are large corporate-style masterpieces. My husband Dan and I are also considering expansion into other island markets in the Caribbean. Along that thought process, comes the idea of donating some nice pieces to the airports, for display in the entrance or lounge area. Then beyond that, we can see making exhibits for hospitals and parks. Then, if things go well, my art will enable us to move our home and studio to the islands which we enjoy so much.

Now with all that's being shared, you might be thinking about time and effort. It's an important consideration, so let me share a few more facts; It's hard to pinpoint, but I have lots of hours of time on my hands, so I put it into the studio. I am very fortunate. Not only do I have time, but my husband is behind me one hundred percent. Going into my "big adventure", I knew what I wanted to create, and where I wanted to sell the art. By chance meeting, I met a nice woman who happened to be a buyer for one of the most prestigious and successful stores on the island of St. John. And as the old saying goes, luck is when preparation meets opportunity.

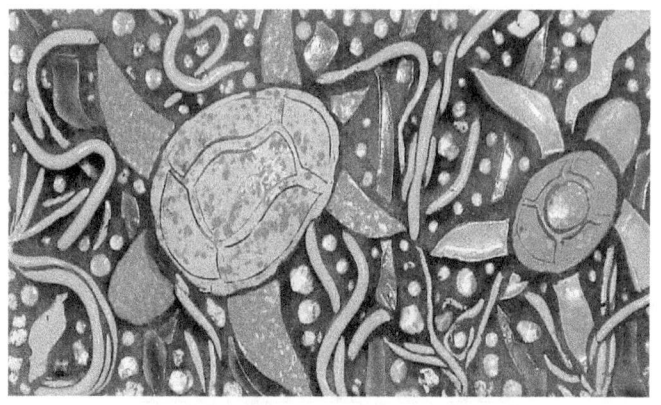

"Turtles," another original masterpiece by Carolyn Frary, only available from Island Screech Studios

We had gone on vacation to St. Thomas with friends. While there, we also skipped over to nearby St. John where one of my friends had lived. A relative still lived there, and by luck, we were introduced. My friend mentioned my ceramic artwork to her sister-in-law, and she became interested, which led to a visit to my studio. (This illustrates the value of networking). She loved what I was creating, and placed an order for several items. Now it's a few years later, and we are still friends, and still doing business.

VARIATION & QUALITY

There are many variables to the success of the studio, you need ideas and ambition first and foremost.

Sometimes we want to be surprised with an outcome in the creative sense, but if you are going to market your creations, and develop a buyer and customer base, then you must have some degree of consistency in quality, so that both you and the buyer know what they getting.

Again, I must stress that I'm not a technical person, but this consideration of where quality, consistency and creativity intersect is important to your outcome, so I have to spell some it out in detail. The International Standards

Organization (ISO) 8402-1986 definition of a standard defines quality as:

"the totality of features and characteristics of a product or service that bears its ability to satisfy stated or implied needs."

In your studio, it'sa measure of excellence or a state of being free from defects, deficiencies, and significant variations, brought about by the consistent adherence to "the way you did it when it came out perfect," to achieve uniformity of output that satisfies your customers.

Eliminate Variation

Maybe that's way too technical for most people, so let's look at this topic from an artist's perspective; In order to improve any activity, or method of performing a task such as making ceramics, pottery, or metal and woodwork, you should be using the same materials, the same equipment, and doing the same thing each time, in each step of your work because *this eliminates the variation.*

What I'm saying is that if you do not stabilize a process by eliminating small variations, and you try improving the outcome, or fix the process, then you are simply guessing, or

"tampering" with what you are doing. On occasion, you may have success, but then again, you may never really know everything that is going on in your own studio!

The artist's mood and creativity produce items of culture

This wastes your time and resources, and can harm your chances of success.

So, you must think long-term! Your art, and your creativity matter for a life-time!

Keep an open mind. Continue to learn, and strive to develop *profound knowledge* about all things.

Consider Contributing Factors

Profound knowledge is all that stuff where everything interacts with each other. When it comes to evaluating any situation, or any problem, or any incident, remember there are always a few contributing factors, some of them not so obvious, which feed into the eventual outcome, including artwork.

For example, I create mermaid figures as part of my Island Screech product line. The mermaids have long hair. I create strands of hair using clay and the bumping process – to give it body and flair. It looks great, however, when I shipped an order of finished artwork, I heard back from the buyer who complained, stating that some strands of the mermaid's hair were broken upon arrival.

This outcome was detrimental to my top goal of making good quality artwork. It could damage the reputation of the Island Screech Studio. The cause of breakage was not part of my process, yet an outside force had become a contributing factor to my art quality. In this type of unexpected situation, I keep an open mind, and think long-term. No shortcuts. The customer matters – they like the product line. The problem must be solved with *knowledge of the process*.

By looking into the situation from start to finish, I discover that the mermaid's hair was too brittle to survive the shipping process. After brain-storming with my husband, we tried a few new methods, eventually developing a new process of making mermaid hair by using pipe cleaners, and small beads. This new process produced mermaid hair which looks great, while also solving the challenge of shipping.

Everything We Do Has Variation

Look at this another way; when brewing coffee at home, what factors contribute to the outcome? Think about it; the average person might be scientific when adding coffee grounds into the filter. A slightly different amount of coffee makes for stronger or weaker coffee. On top of that, the amount, temperature, or quality of the water may be

different, or the brand and quality of the coffee purchased at the store might change from time to time. These slight variations and differences contribute to different outcomes when simply making a cup of coffee. Imagine what it can mean to your studio production!

Don't Guess – Develop Good Habit of Thought

Many times, the average person, when asked about any given situation or problem, will guess at an answer, or state the most obvious answer, which could indeed be the major contributing factor to the situation or question at hand. In the example of making coffee, a person might jump to the conclusion that if a cup of coffee tastes bad, then the brand of coffee being used must be of poor quality. In reality, it bad tasting coffee could be the result of the water, the filter, the coffee machine, or some other factor which is unknown.

For greater success in your studio endeavors, remember to search for, and then consider all possible contributing factors to each situation you are confronting. If you develop this good habit of thought, you will reach a greater level of understanding of all things, and hopefully this will help you reach higher levels of success.

When it comes to my studio operations, I run my kin by computer so it stores my firing programs. I also record various glaze combinations, especially when doing a test fire, these two activities gives me the knowledge control my adjustments.

If you are a ceramic artist, then I recommend that you play around with different glazes and firings. Look for the right time and opportunity to come up with a new twist because no one wants to see the same old thing all the time. It might be true you have to keep your product line fresh, and maybe you have to re-invent yourself.

If you like the results from an experiment, and you kept track of it, you can repeat it. It's all fun! My experiences show some of the best results come from experimentation. Every time you open the kiln there can be a surprise. It can make you feel like a kid on Christmas morning!!! This is the magic of creativity! But once you find your preferred results, it helps to <u>keep it standard for production purposes</u>. That's the challenge.

So in summarizing this chapter, I am suggesting that when you establish which items you are going to make and sell on a regular basis, get the process down, and make as many as possible at the same time. When I make mermaids,

I produce twelve bodies, and twelve tails at the same time, then I work on the hair. This allows me to have stock on the shelves, to have things ready to ship so turn-around time is managed, and customers are not kept waiting.

Finally, I want to drive home the point again to think long-term, always keeping your eyes on quality and consistency. That's why it's not only a great idea to develop profound knowledge of your speciality, and to keep a written log of your habits, ingredients, raw materials, tools, and process, but it is considered a *best practice*.

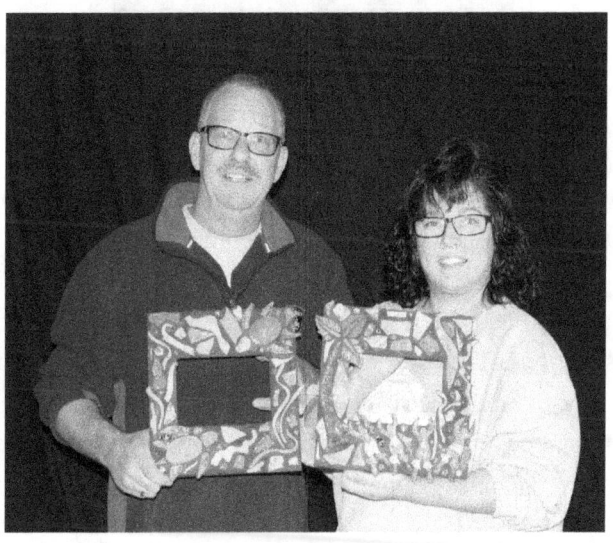

**Dan and Carolyn holding tropic picture frames,
each produced with quality and consistency in mind**

OVERVIEW OF HOW I WORK IN THE HOME STUDIO

The first thing I usually do is put on some music because it helps set my mood for what I am doing, being creative just as the humans did thousands of years ago when the first chairs and cups were created. With music playing, and the distractions of the outside world gone away, I remove about twenty-five pounds of clay from the plastic storage bag it gets shipped in. My favorite clay comes from Sheffield Pottery Company, located in Sheffield Massachusetts.

Raw material –clay from the Sheffield Clay Company

I place the clay down on the work surface, and work it together with both hands, as if I was making big Italian meatballs. It takes just a little effort for a minute or two to reawaken the atoms of clay from their sleepy state.

Once the clay is reinvigorated into a steady, workable state, a smaller piece is cut off using a wire cutter. The wire cutter is basically a two-foot section of thin stainless steel wire.

A five-pound ball of slightly damp Sheffield clay on canvass

A wood handle is attached to each end of the wire. I grasp a handle in each hand, then pull the wire through the clay ball. The wire slices the clay smooth, as if it were a block of cheese being cut at the local deli – same principle. Now comes the process of rolling the clay into *slabs*. This is done between two pieces of damp canvas, which is used over and over again. The canvas prevents the clay from getting into the rollers, which might cause a jam. As the clay is spread out, I use a slab roller to compress and evenly spread the clay out.

Raw material is transformed for the artist

Then I cover the square of clay with another canvas. Once this is accomplished, I used the slab roller to roll out a slab to the thickness of what I am going to make.

For example, if I was making tiles the slab of clay would be approximately 3/4 of an inch thick. Here is where I remind you that environment and mood matters. Certain music puts me into a different mind-set, some for drawing, some for creating and working the clay, and some for the

production process. In this case, I'm usually listening to Simon and Garfunkel's greatest hits.

Once all of the air is removed from the slab and it is the correct thickness for my project, I flipped it onto a board to smooth the surface, then begin tracing a pattern onto the clay.

Then I cut out the pieces which I traced and let them sit for approximately 30 min.

When I am drawing a pattern for a new creation, I like to put on Joe Cocker's greatest hits, and just draw what I envisioned in my head onto tracing paper. I find this works best for tracing design on the clay.

While I am waiting for the clay to set a little bit and become a little bit harder, I look around and make sure that my housekeeping is in good order and that I am ready to move quickly because, let's face it every minute counts when you're in the studio in your producing. You don't want to waste time. If you are going to do this for money as well as enjoyment then you need to be smart about it.

Now that I have the pieces that I have drawn and cut out I start to commence a process which could be called bumping, that is I'd bump out with my hand certain ones to create the illusion of movement, and a 3-D effect.

Once I am satisfied with the process of creating shape in movement, I placed the pieces on racks to try. This drying process takes about three days.

After several days have passed, I load those pieces into the kiln. At this stage of the process the pieces are called green-ware. The kiln has several different settings, so on this process I will set the computer on the bisque mode, and set the computer for the desired time.

Twenty-four hours later, I unload the bisque clay and lay it out on a well lit, workable surface. Now I am ready to apply the glaze. As I stated before I like to use different types of music for the different process involved in making a ceramic piece, so right now I listen to Jimmy Buffett. His music puts me into superhigh gear which is necessary because if I'm going to be glazing one thousand pieces it does become tedious work.

During this stage, you have to consider brush selection. I use brushes called mop brushes. They are different sizes depending on how large the piece is that I need to glaze. I usually purchase my brushes from Clay King.com. Just a reminder, it's important to clean the brushes right away with very hot water because they are expensive and if you take care of them, they will last forever.

Because I focus on Island art, I tend to use what I call funky colors, and no pieces are the same. Glazing is painting glaze onto this bisque pieces, and I usually put three coats on each piece before loading those pieces back into the kiln to fire in a glaze. Believe it or not, this is going to last another twenty-four hours before I unload the kiln.

Now I'm organized, and I still have my Jimmy Buffett music playing. I take my creations out and I began to glue them onto the back boards. The back boards, a normally 3/8 inch thick plywood. This type of surface is durable, yet not too heavy.

The type of glue I use at this stage is DAP 3.0 adhesive. I apply the DAP 3.0 to the board, placing the pieces in a random manner. This is where creativity comes into play – it's a vision within your mind. I always find it more fun to do it that way! The glue must be given sufficient time to try because you watch your pieces to be very durable, basically to last a lifetime. Now the grouting phase is underway. I you normally use black-sanded grout for my artwork.

Applying DAP 3.0 Adhesive

SELLING YOUR ARTWORK

The first step in the selling process is to define your market. This is simple – just ask yourself this question; Who would be interested in buying what I'm making?

By taking a few hours to look into markets, and letting your mind wander, you will develop a deeper insight into who might be interested in talking to you. It's not easy – selling never is. Your sales plan should include the accounts you want to sell to. So, start out by picking your customers. Take the nice and easy approach, and prospect as often as possible. Success won't happen overnight. Think long-term!

Be patient. People might not pay attention at first, or you might run into a lower level administrative person who does not, or cannot make the decision to buy. Just be nice and get your name and product out there.

Be courteous. Everywhere you go, leave your mark! Think about Island Screech, represented by my pet bird Screech, featured in almost every chapter of this book. Do you think you will forget Screech after you finish this book? Probably not. He is a "reminder trademark" for my theme of island art. Even though Screech kept popping up, he never insulted anyone because he's an image. So, my advice is to develop a good image.

Direct Selling. Consider selling direct-to-consumers through a website, or through traditional venues such as art and craft shows. Again, it's a slow process getting everything set up. It can't be done overnight, so take one step at a time. My husband and I purchased a web site domain which is up and running. Visit it today: www.islandscreech.com.

Direct selling is easier now because technology brings us things such as small credit card readers, which plug directly into your smart cell phone. So, if you have a high-tech phone, and a card reader, and if a buyer does not have cash,

they can use their credit card, but only if you are ready to handle such a transaction!

As you build up an inventory of items to sell, develop a sell-sheet. Provide the sell-sheet to independent retail stores, or their buyers. Buyers are busy people. They like it simple, fast, and easy, so don't over-do it!

Finally, follow a proven process for growing sales over time. While it would be fabulous to have Wal-Mart carry your product right out of the gate, it may not be realistic. Most large retailers want to see a record of successful sales at another store before agreeing to take on a new product. Just remember that there are thousands of retailers who need good things to sell!

Build Your Market Potential

To learn how to bring a product to market, begin by selling directly to the public at a fair or art show. This will give you confidence that there's demand for your product and will also create customers that you can contact for product and packaging feedback before you hit the bigger leagues.

Remember to follow up, and put action dates on your calendar so you can operate your studio in a methodical

manner. You also want to be at art shows, and art shops, and off-the-wall places where you might sell a few pieces a month, but it all takes planning, especially to make a reservation at an art show – sometimes you have to do this one year out.

So where can you reach the people who buy for stores? You'll probably start with the internet search engines, then go out and visit independently owned, local stores. It's a good idea to start with them before hitting large chain stores because it's easier to make contact with the decision-maker. They are more inclined to take on unique artwork to differentiate themselves from larger stores. To sell to these retailers, be prepared for a fast sales presentation. Ask them if there is something you can produce just for them. Bring your printed materials, an introduction letter, your brochure, and maybe two samples. Establish rapport with the potential buyer, and then, when the time is right, explain why your creations are good for the store.

Use the internet as a marketing tool, but don't try to email everyone over and over again, or you will be handled like SPAM. You can reach your market through your own website. Again, Island Screech has its own web site, which comes up quickly in the search engines. I know people can find me if they are looking. Just the same, it's up to me to

prospect for buyers, and get publicity. It's my job to make people aware of my art. Awareness brings buyers to the web site, while courtesy and follow-up conversations, containing invitations to buy an item, is what leads to purchases.

You can also tap into your own personal network as you begin. Host a home party to share your product with friends and friends-of-friends, sell through local community groups and e-mail your network. Once you get feedback directly from your customers, refine the packaging and price point before approaching your next market--wholesalers. Ask people why they did not purchase. You might learn something valuable in the process of asking for this feedback.

Expand to New Markets

Find out who the buyers are, or hire a distributor or manufacturer's rep (on commission) who already has established relationships with small retailers. Practice your presentation with your professional-looking materials in hand. Finally, wrap your artwork with packaging that's ready to go. (Remember the hidden challenges of shipping, as illustrated by the lesson of the mermaid's hair.)

With all of that said, it's time for me to get back to my studio where I can be creative. Hopefully my advice will be useful if you were considering a home studio. Now it's time to just do it! Move ahead one step at a time, but not alone, but with family and friends, and a love for art!

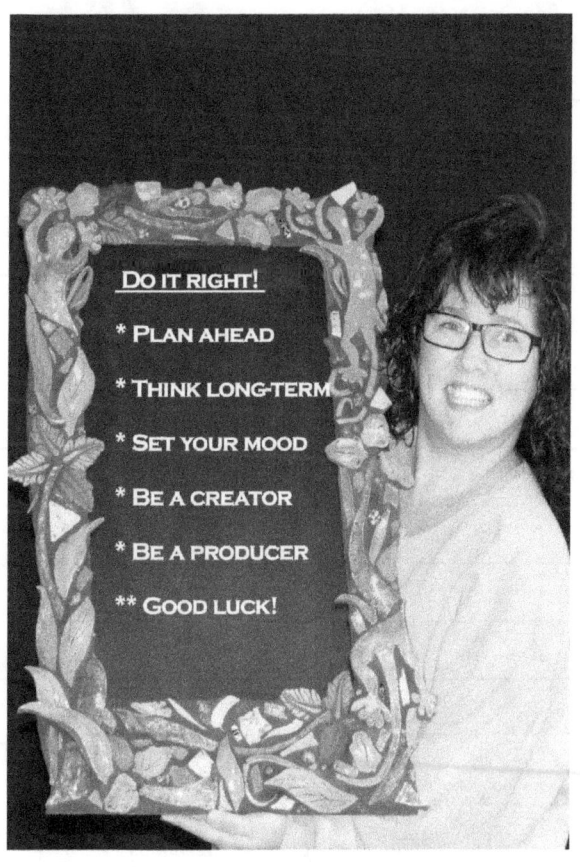

YOUR VISION

IDEAS & POSSIBILITIES

ACTION ITEMS

ACTION ITEMS

POTENTIAL CUSTOMERS

www.ingramcontent.com/pod-product-compliance
Lightning Source LLC
Chambersburg PA
CBHW061516180526
45171CB00001B/198